DRAWING WITH
COLORED
PENCILS

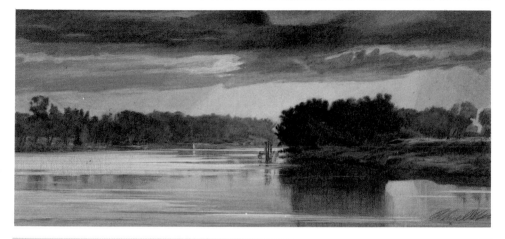

By Morrell Wise

Walter Foster Publishing, Inc.
430 West Sixth Street, Tustin, CA 92680-9990

TABLE OF CONTENTS

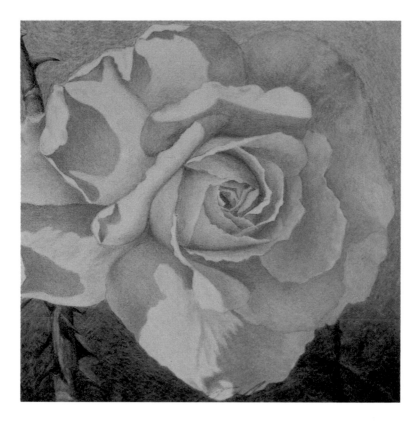

INTRODUCTION

For many years, colored pencils have been an accepted medium for the commercial artist, designer, architect and many other related professions. In recent years, colored pencils have joined the ranks with the other acceptable fine art mediums. It is a wonderfully usable medium-- perfect for sketching or rendering, and mixes well with other mediums in mixed medium drawings or paintings.

On the following pages, I have demonstrated and discussed some of the techniques I have learned. I sincerely hope that you will enjoy this book, and I hope perhaps in a small way it might help you in your work as well.

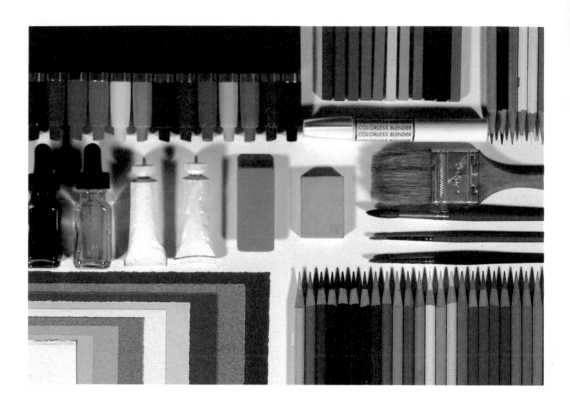

MATERIALS

The first thing I would like to say is that this is not necessarily a complete list. The materials used in one project will vary to the next. I encourage you to try new and different materials. It can be very inspiring to find some new and interesting supplies with which to work. I have always been interested in new papers. If I find something with a new texture or feel, it can inspire a whole series of new works. It would be impossible to list everything I have tried, however, the following is a list of some of my favorite materials.

COLORED PENCILS

Since the focus of this book is on pencils, it would be an appropriate starting point. I have tried many types, but my favorites are those made with bee's wax. I use both the hard and soft kind in as many colors as are available.

ART STIX

This product is somewhat like pastel except, like the pencils, it has a bee's wax base. They come in a good range of colors. They are slightly softer than colored pencils.

PAINTS

I use watercolor paint for under-colors. I sometimes use shades of grey to fill in the value scheme. I also use transparent water-color dyes. The dyes are usually used on top of colored pencils rather than as an undercolor.

BRUSHES

An assortment of brushes is best. Use a wide one-and-a-half or two inch brush to block in large areas of color. I have found a Number Three water color brush to be good for smaller more detailed work.

PAPERS

Try every paper you can find. The type of paper you use can make all the difference. I use hot and cold pressed watercolor paper, high surface and medium surface bristol board, pastel paper, charcoal paper, tracing paper and an assortment of tinted papers. For permanence, it is best to use a 100% cotton paper whenever possible.

COLORLESS BLENDER

This item is like a felt pen without the pigment. It will melt the wax-based colored pencils. It is used for blending, spreading undercolors and special effects. This item can save time and is worth trying.

FELT PENS

I use the full range of colors and the greys. They work well for undercoloring. The thing you must remember is that most, if not all, felt pens are fugitive, that is color is not permanent. I use them for sketching, planning and thumbnail drawing.

COLORED PENCILS ON PAPER

(1) Figure One, demonstrates the light application of one colored pencil to white paper. Notice how the texture of the paper is revealed. Light reflects from both the fragments of color and the white of the paper.

(2) In Figure Two, the white paper has been completely covered with one layer of color. There is no paper visible between the fragments of color. The result is a darker and more brilliant color. This technique is known as burnishing.

(3) In Figure Three, the paper has first been completely covered with one color, and then a second color has been lightly applied. The result is that the fragments of the second color define the texture of the paper while the first layer of color is visible between those fragments. The first layer of color may be accomplished with any one of a number of mediums. For example, watercolor, felt pen, colored pencils with colorless felt pen blender or, as demonstrated here, a single layer of colored pencil.

THE VALUE SCALE

Perhaps the single most important principle in learning to make pictures is understanding the value scale. It is simply a series of tones ranging from the very darkest to the very lightest. It is very helpful to number these values, ten being black, one being white and two through nine being the shades of grey in-between. You don't necessarily have to draw it out. Just keep it in your mind. After first making your line drawing, you use it to determine the relationship between the dark and the light areas of your picture. Then, while looking at the scene you wish to draw, decide what area is the darkest and make that area the darkest value of your drawing. Next, decide which is the lightest, and leave that part of your drawing white. Then logically decide where the rest of the values go by looking at your subject and thinking about what you see. It is much simpler than it sounds. Remember, the human eye sees more in terms of dark and light than it does in terms of color.

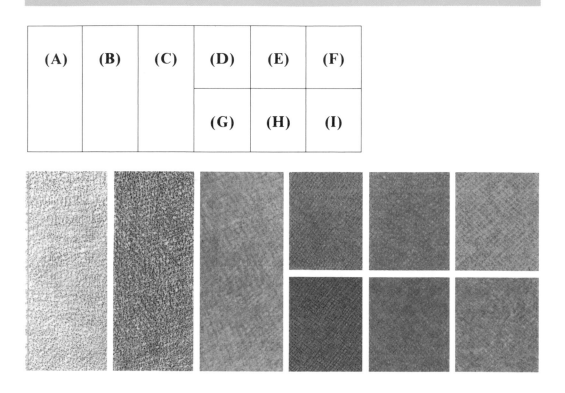

(A)	(B)	(C)	(D)	(E)	(F)
			(G)	(H)	(I)

BASIC LAYERING TECHNIQUE

This demonstration is to illustrate the basic layering technique I use when rendering with colored pencils. Colors are applied in layers, then burnished over with White, and then reapplied. In areas **A** through **I,** Indigo Blue has been applied. Then in areas **B** through I, Tuscan Red has been added. In areas **C** through **I,** the colors have been burnished and blended with a layer of White. Then in areas **D, E,** and **F,** Indigo Blue was again applied. Then in areas **G, H** and **I** Tuscan Red was applied. Next areas **E, F** and **H, I** were burnished over with another layer of White. Then areas **E** and **H** have a layer of Orange, and areas **F** and **I** each have a layer of Apple Green. In this manner, you can create any number of colors. Notice that the colors in **D** through **I** seem to go well together. This is because they were all made on a foundation of Indigo Blue and Tuscan Red. I urge you to try this on your own. First hand experience will show you the true richness of these colors.

(A)	(B)	(C)	(D)	(E)
	(F)	(G)	(H)	(I)
	(J)	(K)	(L)	(M)

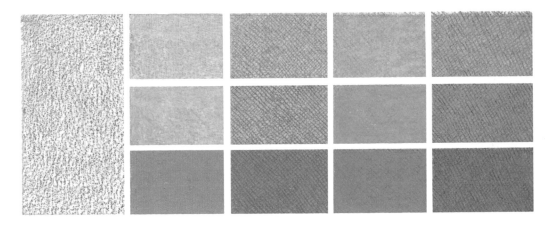

USE OF WHITE AND OTHER OPAQUE COLORS

In areas **A** through **M**, Indigo Blue was evenly applied with the point of the pencil. In areas **B** through **E**, **F** through **I**, **J** through **M**, the same basic technique was used. The difference is that in areas **B** through **E**, a cream color was used; in areas **F** through **I**, white was used; and in areas **J** through **M**, a grey color was used. White, cream, and grey are opaque colors.

THE TECHNIQUE WORKS AS FOLLOWS:

Indigo Blue is first applied. Then the opaque colors are applied, in areas **B** through **M**, over the blue. This also blends the blue. Then the blue is reapplied in areas **C** through **E**, **G** through **I**, and **K** through **M**. The opaques are again applied in areas **D** and **E**, **H** and **I**, and **L** and **M** to blend and smooth the blue. Once again, the blue is reapplied in areas **E**, **I** and **M**. This final application gives a glazed and textured effect.

COLORED PENCILS AS A MIXED MEDIUM

The following plates demonstrate six ways in which colored pencils may be used in conjunction with other mediums. These techniques as well as others will be demonstrated in further detail later in this book.

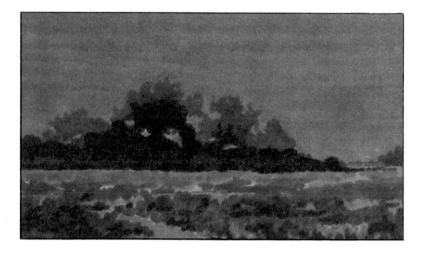

1) COLORED FELT PENS WITH COLORED PENCILS

In this first example, the undercolors have been applied using colored felt pens. Reds, browns, tans and Olive Green were used to create the dark undercolors.

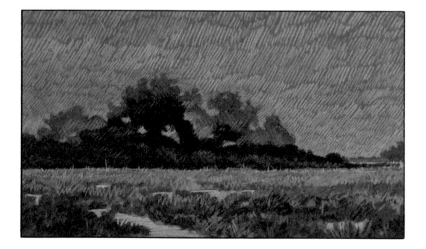

1a) Next, the sky was drawn in with Cream, Orange, Canary Yellow and Light Violet colored pencils. The trees and land mass have been filled in using Apple Green, Olive Green, Light Violet and a small amount of Cream color.

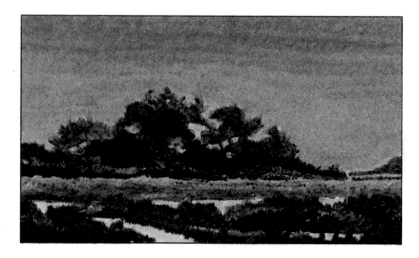

2) COLORLESS BLENDER WITH COLORED PENCILS

In the first step, the values have been filled in with black colored pencil. Following this, a colorless blender is used to melt and blend the black into smooth values. A colorless blender is a felt pen which contains only the solvent without the pigment.

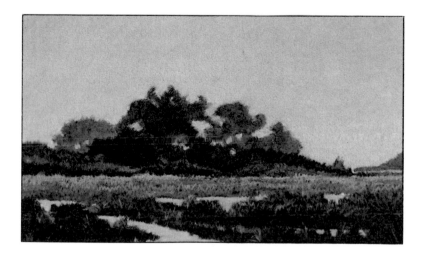

2a) After the values have been completed, color is added to the picture with colored pencils. In this drawing I used Light Blue, Lavender, Copenhagen Blue, Olive Green, Apple Green, True Green, Grass Green, Violet, Pink and White.

3) TINTED PAPER WITH COLORED PENCILS

The line drawing is transferred onto an evenly tinted paper. You can tint the paper yourself with felt pen, ink, watercolor; or, as I have done here, use a store-bought tinted paper.

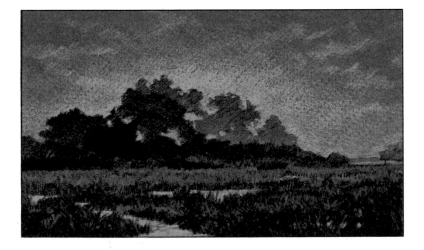

3a) Next, the drawing is done allowing the color of the paper to show through consistently through the image. This was done with Dark Grey, Indigo Blue, True Blue, Flesh, Olive Green, Apple Green, Sand, Light Violet and White.

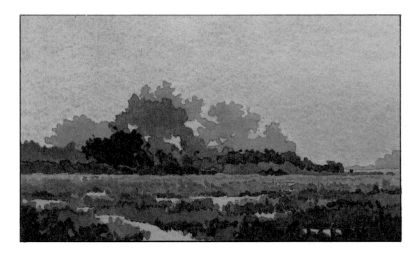

4) WATERCOLOR WITH COLORED PENCILS

With this technique you begin by blocking in the values with watercolor. In this case it was done with Cadmium Orange, Thalo Blue, Burnt Umber and Raw Umber.

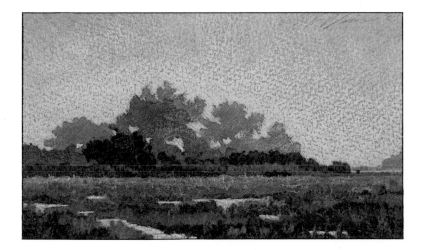

4a) Drawing over the watercolor with colored pencils, I used Blush, Pink, Carmine Red, Lavender, Crimson Red, Sand, Cream, Violet, Grass Green, Olive Green, Apple Green and Green Bice.

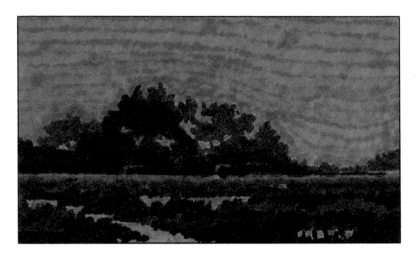

5) GREY FELT PEN WITH COLORED PENCILS

The value scheme is first filled in with an assortment of grey felt pens. This technique is very fast and easy to use for quick studies.

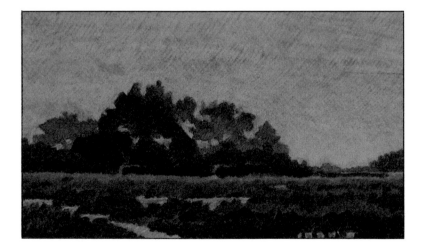

5a) The next step is to draw over the image with colored pencils adding the color and details to the drawing. In this drawing, I used Pink, Non Photo Blue, Sand, Cream, Olive Green, Apple Green, True Blue, Indigo Blue and White.

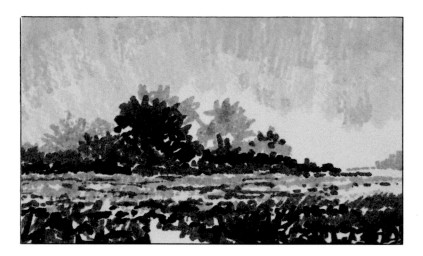

6) SKETCHING WITH FELT PEN AND COLORED PENCILS

The image is first drawn directly on the paper with grey felt pens. In this drawing, a rough watercolor paper was used.

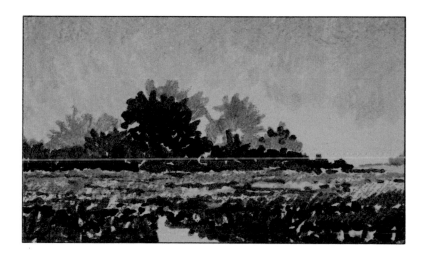

6a) A little color is added to the sketch to get a feel for the atmosphere. In this case I used Blush, Cream, Apple Green, Sand, Light Violet, Olive Green and Green Bice.

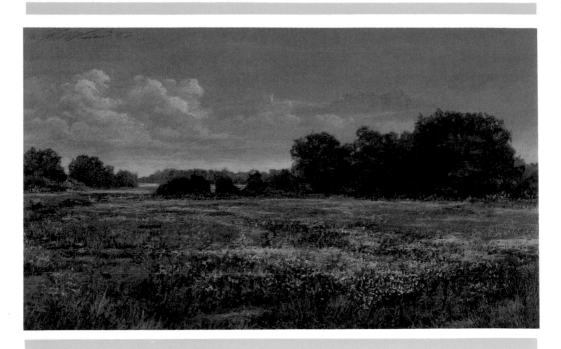

HOW TO BEGIN

In time, most artists establish methods of working which help them arrive at the desired product. This method usually consists of a combination of techniques performed in a series of steps. There are several steps which are a usual part of my procedure. You will see these techniques, perhaps with some variation in the pages to follow. The following is a list of these techniques:

SELECTING THE MATERIALS AND MEDIUM

At this point, I decide the type of paper, the medium and the kind of undercolor I will use. Refer to Page 4.

ROUGH LINE DRAWING

In this step, I usually make a rough sketch to determine the composition. Sometimes this is done with a bold felt pen. Other times with a soft pencil.

REFINING THE DRAWING

Placing a piece of tracing paper over the rough drawing, I make a detailed line drawing of my subject. Sometimes this step is repeated several times until the line drawing is satisfactory.

16

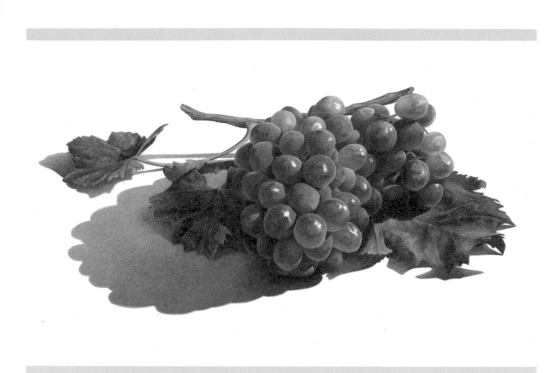

TRANSFERRING THE LINE DRAWING

At this time, the drawing is transferred to the art board or paper using either carbon paper or the graphite transfer method (See Pages 28 through 31). At this point, the line drawing should be sharp, but faint on the art board.

BLOCKING IN THE UNDERCOLORS AND VALUES

Next, the values are filled in, either with watercolor, felt pen or colored pencils with colorless blender.

FINAL COLOR AND DETAILS

The final colors and details are added on top of the values and undercolor with either colored pencils, art stix, or both.

FIXATIVE

The drawing is fixed with a standard drawing fixative. When using colored pencils or art stix, this step is a must.

SKETCHING

There are a lot of good reasons for sketching. One person might do it to enhance their drawing skills, while another might do it for fun. I do it because it gives me a chance to be creative. In this section, I have shown you some sketches along with the actual scenes. Please notice the changes.

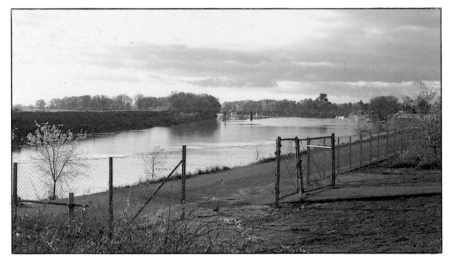

SKETCH NO. 1

This is a scene taken from one of my favorite spots along the Sacramento River. My main interest in this sketch was the clump of trees at the river's bend, roughly in the center of the picture.

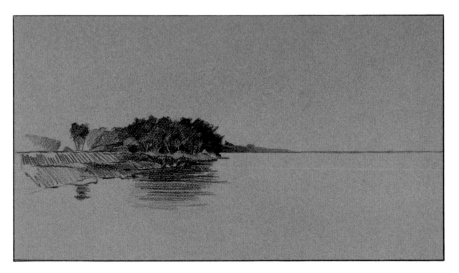

1a) In this first step, I have done the rough drawing on a grey tinted paper. I have completely eliminated the foliage on the right. I have tried to give this scene a feeling of wide open space.

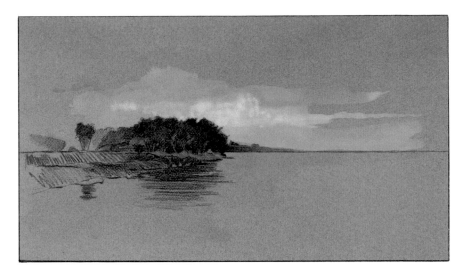

1b) The next basic step was to add color to the scene. This was done very quickly with watercolors. I used Prussian Blue, Hookers Green, Yellow and White.

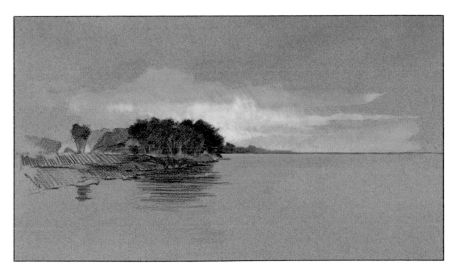

1c) The final step was to add a little texture and detail using colored pencils. In the sky, I used Non Photo Blue, Light Violet and White. To the trees, I have added Olive Green and Apple Green; and in the water I used Non Photo Blue.

19

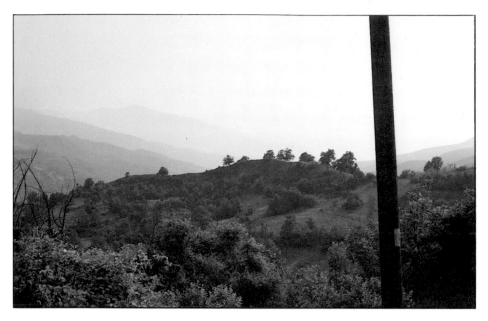

SKETCH NO. 2

This picture was taken in Greece. I like the way the lines of the distant mountains and the ridge create a focal area. In the sketch, I have further enhanced this focal area by enlarging the group of trees along the ridge.

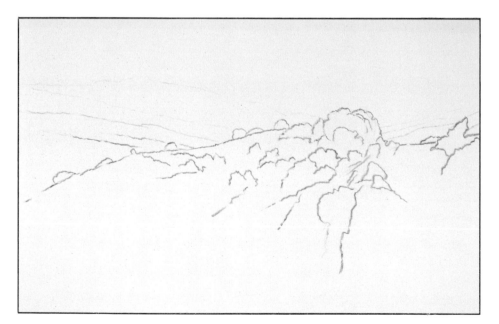

2a) First the line drawing was made with black colored pencil on white paper. Notice how the proportions have been changed to center your attention on the main group of trees.

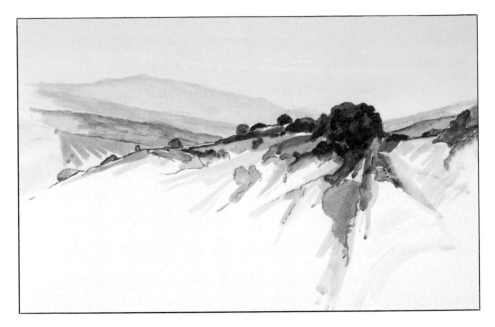

2b) Next the values are quickly filled in with black watercolor. Notice how focalization is further achieved by increasing the contrast of the values in the focal area.

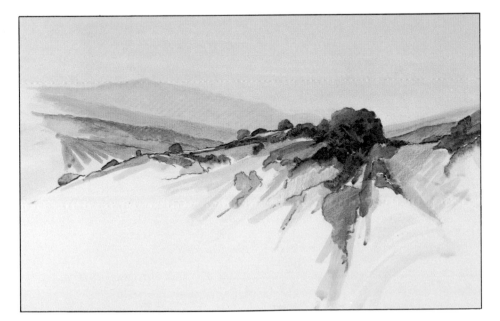

2c) In the final step, the color was added with colored pencils. Notice how little the value scheme changes. In the sky, I used Cream, Sand and White. In the foliage I used Cream, Pink, Light Violet, Olive Green, Apple Green and Green Bice.

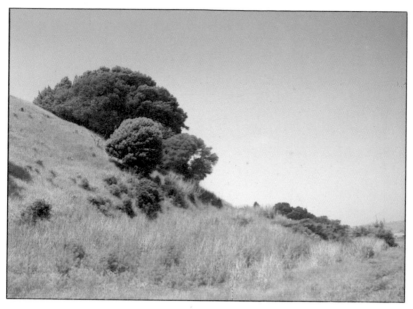

SKETCH NO. 3

This slide is a fairly typical view of the foothills of California. I have made the pitch of the hill steeper and have added and changed some of the foliage to suit my design.

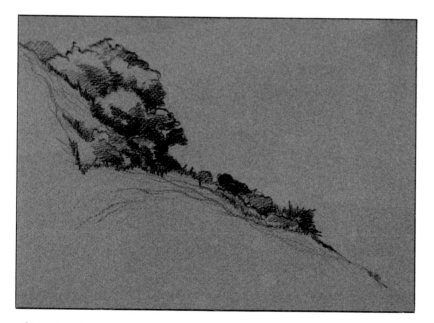

3a) In the first step, I have used a black colored pencil to rough in the line drawing on a grey tinted paper. Some of the values have been added to establish the focal area.

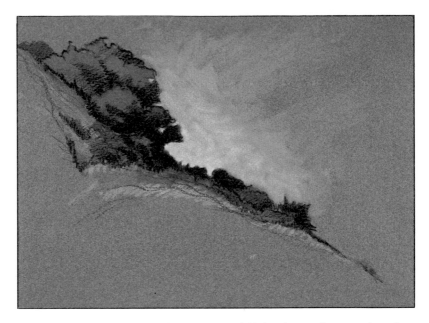

3b) In this step, I have used watercolor to establish the value and color scheme. White was used to enhance the contrast between the trees and sky. The trees and foliage were filled in with Prussian Blue, Olive Green, Hookers Green, Magenta and Yellow.

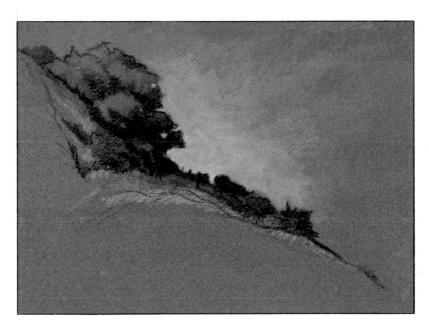

3c) For the finishing touches, I used colored pencils to add some texture and richness to the color. In the sky, subtle amounts of Non Photo Blue, Light Violet and Cream were used. True Blue, Apple Green, Green Bice, Scarlet Lake and Pink were added to the trees and land mass.

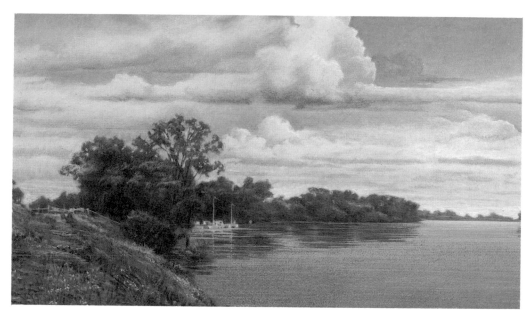

FIGURE (1)

NATURAL PERSPECTIVE

The dictionary defines perspective as the proper relative position of objects. To understand natural perspective, you have to see the underlying logic behind specific effects which occur in nature and recreate these effects in your picture to make it appear natural. Natural perspective also has to do with space and the diminishing effect of space. In the following pictures, you will see some of these effects. As you look at them, try to imagine how these effects could be used in your pictures.

FIGURE (2)

SIZES

The first and most obvious effect of natural perspective is the difference in size between foreground and background objects. The farther an object is from the viewer, the smaller it looks. This effect is easily achieved by making the objects in your picture reduce in size as they approach the horizon. When you're working outdoors, make a point of looking at this effect. See just how much something reduces in size given the distance that object is from the viewer. When working from photographs or slides, this effect can be distorted, depending on the type of lens you're using. So, it is best to observe this effect on location. Look at Figures 2 and 4.

DETAILS

The closer an object is to the viewer, the more detail the viewer can see. Notice, in Figures 1 and 2, how much detail is in the foreground and how little detail appears in the background.

FIGURE (3)

ATMOSPHERE

The greater the distance between the viewer and the subject, the more the subject's color is affected by the color of the sky. Look at the atmosphere in Figures 3 and 4. You must be careful not to grey the color too much as the objects recede into the distance. This can create an effect of too much depth which can disrupt the picture plane. You should try to keep the intensity of your colors consistent throughout your picture.

FIGURE (4)

VALUES

This element of natural perspective is one of the most important. This is because the human eye sees things more in terms of darks and lights than it does in terms of contrasting color. Generally speaking, the foreground has a greater range of values than the background. Foreground details will also have a greater range of contrasting values when compared with background details. Look at Figure 3.

All of these elements: size, detail, atmosphere and value; work together to give the viewer the necessary information to understand the expressive qualities of your landscape. Learn to use these expressive qualities and your work will improve greatly. Your powers of observation will also improve. And, as you learn to draw or paint landscapes, you will begin to understand the principles of natural perspective. You will also begin to understand the principles of design and composition. Sometimes these principles oppose each other. In these cases, it is always better to first consider the design or expressive qualities of your picture.

WATERCOLOR WITH COLORED PENCILS AND ART STIX

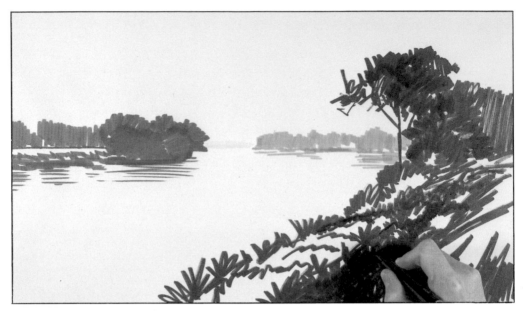

1) The first step is to compose the picture. I used felt pens to combine foreground, middleground and background. I obtained each from separate 35mm slides.

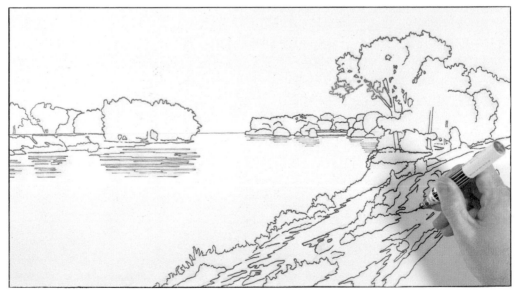

2) I then refined this drawing by tracing it onto semi-transparent paper.

3) To transfer this drawing to the art board, first turn it over and trace over the lines with a soft graphite pencil.

4) The drawing is, again, turned over and firmly attached to the art board. The next step is to retrace the existing line drawing with a hard color pencil. This way, you can easily keep track of what has and has not been retraced.

5) In this step, you can see how the graphite from the backside of the tracing paper has now been transferred to the art board. In this case, the art board is a standard watercolor paper.

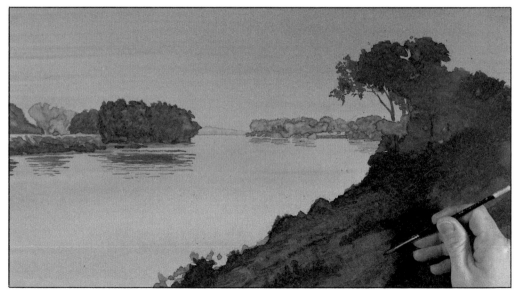

6) Next, the value scheme was painted in with watercolor. I used Hooker's Green and Alizarin Crimson to make a neutral color.

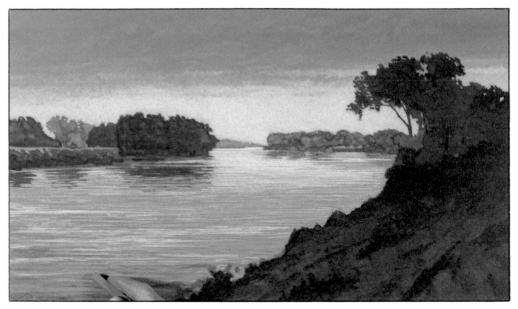

7) In this step, I have used colored pencils and art stix to add color to the sky and water. In the sky, I used Light Blue, Non Photo Blue, True Blue, Olive Green and White.

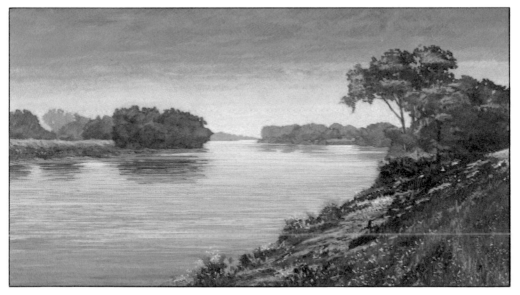

8) Here, the drawing has been completed. Pink, Flesh, and Cream were added to the sky and water. Most of the trees and foliage were filled in with Olive Green and Apple Green. The sky colors were also used in the greenery. The farther away the land mass, the more sky colors are used. The foreground details were added with White, Yellow, Green Bice, Light Blue, True Blue, Violet, Light Violet and Scarlet Lake.

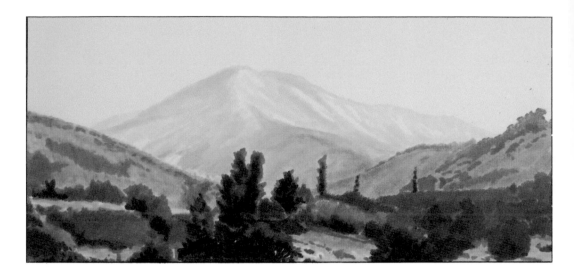

1) The first thing I did with this drawing was design the composition. It is a composite of two scenes taken from separate slides. I used grey felt pens to work out my plan.

2) After my plan was complete, the next step was to make a refined line drawing. This line drawing was then transferred onto grey tinted art board. This was done with a kind of homemade carbon paper made from graphite and tracing paper.

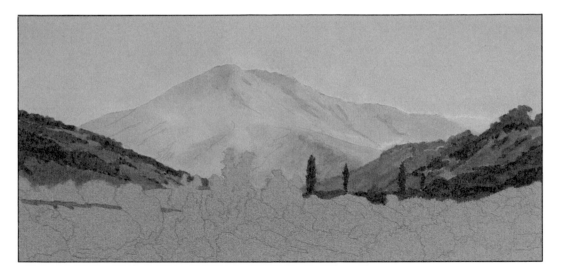

3) Next, the sky and mountain were painted over with a layer of white watercolor. At this point, some of the detail in the mountain begins to show. The middleground was painted next with shades of grey.

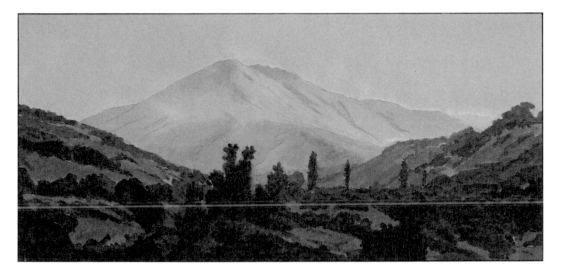

4) In this step, the foreground is also completed with shades of grey. Despite the absence of detail, the viewer can now get a fairly good idea of what the scene will look like. Keep in mind it is the value scheme, not the details, that allow us to see the picture.

5) Next, color is added to the mountains and sky. Notice how little the value scheme has changed, but now the expressive quality of the work begins to emerge. The colors used were Cream, Sand, Pink, Non Photo Blue, Light Violet, Flesh, Blush, White, Olive and Apple Green.

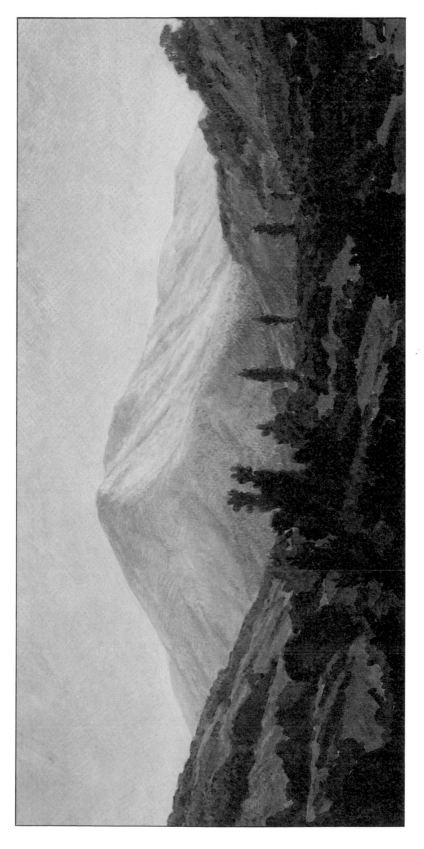

6) The color and detail of the middleground are added to the picture. Notice the color relationship between the middle and background. The middleground is less effected by the atmosphere than the background. The colors used in this area were Olive Green, Apple Green, Light Violet, Violet, Tuscan Red and Golden Brown.

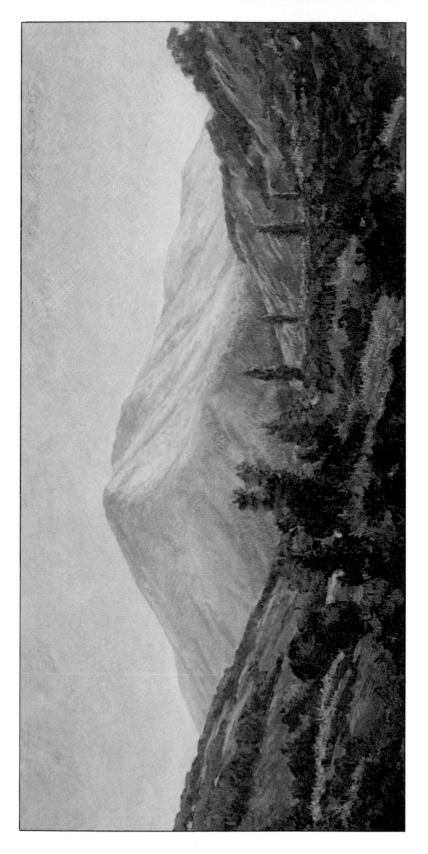

7) The final step is to complete the foreground. I have used most of the same colors and have added Grass Green, Green Bice, Orange, and Raw Umber. At this point, it is time to check perspective. (See pages 24-27.)

FELT PENS WITH COLORED PENCILS

1) In the first step, the line drawing has been transferred to a grey tinted paper. I have made the line bold so it would reproduce well for this book. However, in your own work, try to make it as subtle as possible.

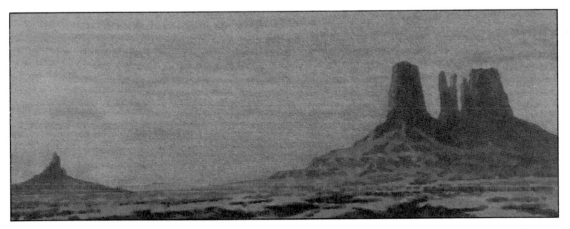

2) In the second step, five different shades of grey felt pens were used to draw in the value scheme. At this point, the image is still a little unclear and the sky is much darker than it will eventually be.

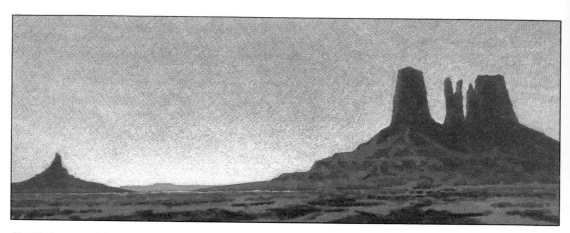

3) Using a white and very light grey colored pencil, the sky was filled in. Notice the sky is lightest at the horizon line. Also notice the contrast between the mountains and sky. The edges are now much clearer, and the image is beginning to take shape.

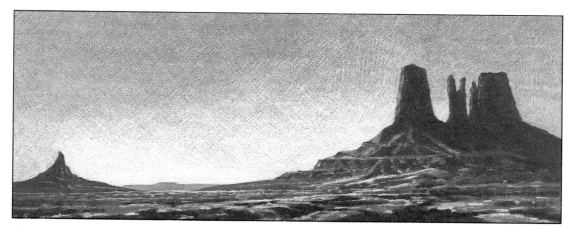

4) Next, the highlight details have been added to the land mass using White, Very Light Grey and Light Grey. Notice that the foreground details have the greatest contrast between highlight and shadow. The mountain is becoming more three-dimensional, and is no longer a silhouette.

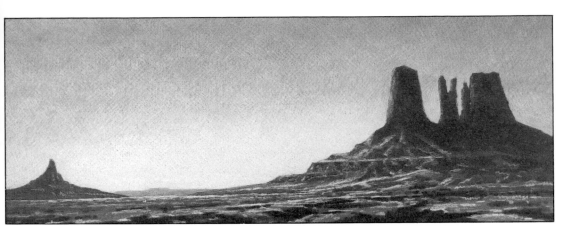

5) Now that the image is visible, you need only add some color for expression. In the sky area, I used Cream, Golden Brown, Sand, Yellow Ochre, Light Violet, and Light Blue. I have left the lower portion of the sky lighter because I would like to bring some attention to that area.

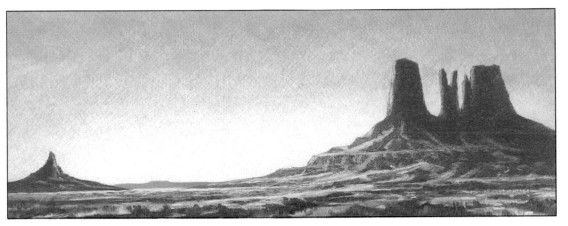

6) In the next step, Purple, Crimson Red, Olive Green, Pink and Light Violet have been added. And, finally, Apple Green was added to the highlight areas and sky. Although it is, perhaps, a little exaggerated in this picture, you can now see the color relationship. Notice how the Apple Green has brought the color scheme together.

PASTELS

Although the major focus of this book has been on colored pencils, I would like to take a few moments to discuss pastel drawing. For years, I was told that pastels were too difficult and messy. This is really not true. In fact, pastels are a wonderful drawing medium with a unique character. If you work with them for a while, I'm sure you will agree.

1) In Figure 1, I have completely covered the papers with a middle-tone grey. Then, with a violet-colored pastel pencil, I have added my line drawing.

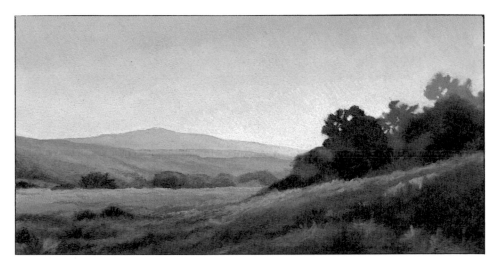

2) I have built the image entirely from grey tones. This establishes a value scheme. Your value scheme is important. Without it, your image can look flat and uninteresting.

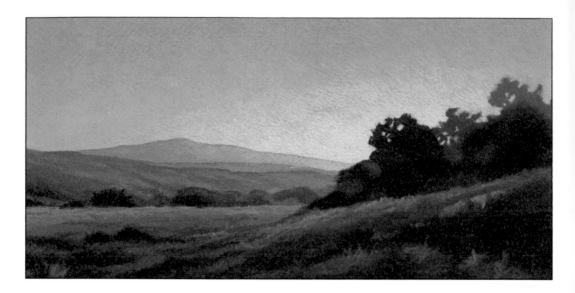

3) I have begun to add color to the image. First, some Pale Yellow and Pink in the sky. Then, some Pale Yellow, Pink and Blue to the distant mountain. When you begin to add color to your image, try to use a color with the same value (that is, quality of darkness or lightness) as the tone already in that area. In this way, your value scheme becomes a kind of plan which you can follow to the completion of your drawing.

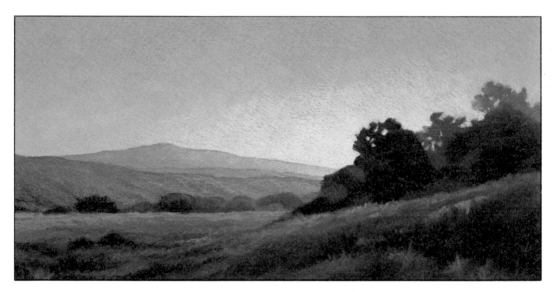

4) Next, I have continued adding color to the drawing. Notice that the colored areas are still about the same tone value. In these areas, I have started to introduce some greens and blues with the pinks and yellows.

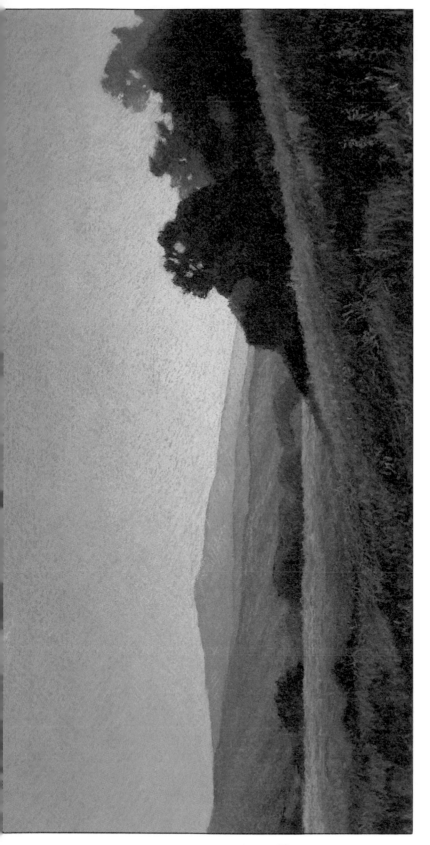

5) Figure 5 shows the finished pastel drawing. Notice that my values (darks versus lights) are about the same as my original plan in Figure 2. I have added some richer greens, blue-greens, blues and violets to describe foreground and middleground details.

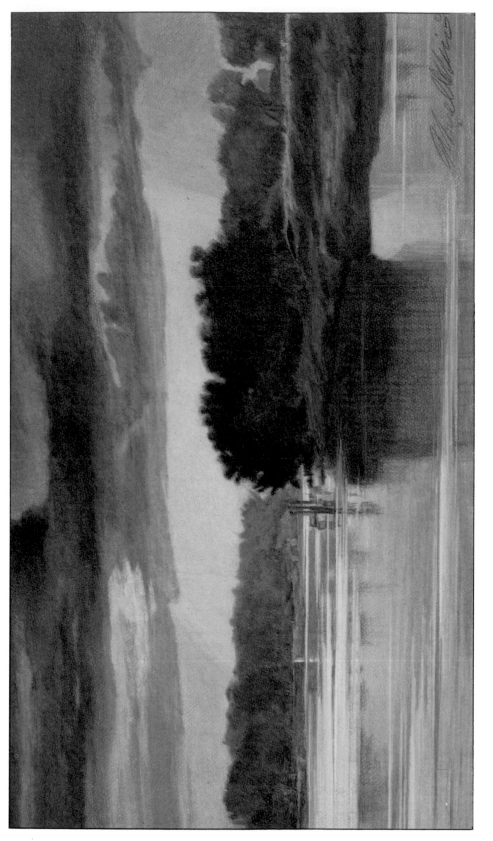

SACRAMENTO RIVER
DETAIL

44

SACRAMENTO RIVER

One of the most basic ideas in art is to create your composition with a sense of order, and give it enough variety and personal feeling to make it interesting and expressive. Whether you create art yourself or just like to look at art, it is your own personal feelings which influence what you do with your composition or what you see in someone else's composition.

A piece of art should express something. As the artist, when I look at this piece of art, I know exactly what it expresses. However, I cannot use words to express the same idea. The visual arts each have their own unique vocabulary. Each artist works at developing his or her own vocabulary of visual techniques which express the kinds of ideas which they wish to express.

In this picture, I tried to create a sense of limitless space. I established lines which would carry the viewer's eye from one end of the picture to the other then continuing right off the end of the page. In doing this, it gives the viewer the feeling that the picture continues outside the limits of the format. The central theme of this picture is the dark clump of trees slightly to the right side of center. I made this my focal area by giving it the highest amount of tonal contrast. Also, notice how the horizontal lines which cut through the center of the picture lead the eye directly to this area. The stillness in the water gives the viewer a sense of calm. The contrast in size between the clump of trees and the boats in the water give the viewer a clue to the mass and scale of the trees.

There is a lot of information in this picture. I have tried to organize it in such a way as to express my feelings about the scene.

RENDERING WITH COLORED PENCILS

1) In the first step, the line drawing has been transferred onto a sheet of 100% cotton paper.

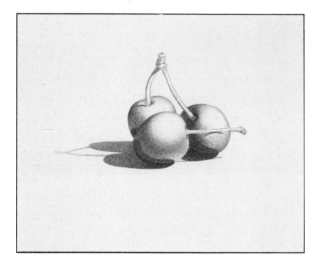

2) The image begins to take shape with the first layer of Indigo Blue

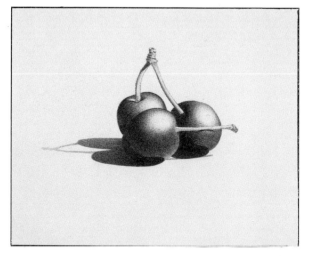

3) Next, a layer of Tuscan Red covers the image. Together, these two colors make up a color which acts as an undercoat for the final colors.

4) In this step, I have added Crimson Lake and Scarlet Lake to the cherries only. Then, they are blended with a white pencil. Next, I reapply the two reds. Also, I used light violet to add reflected light to the bottom of the cherries.

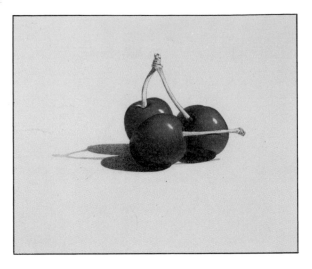

5) I have used Orange, Apple Green and Cream to make up the color of the stem. I have also used a white pencil to blend the color in the shadow.

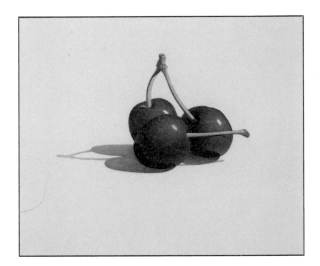

6) I have added Apple Green to the shadow along with layers of Tuscan Red and Indigo Blue. Next, I added Yellow, Orange, Apple Green and Red to the edges of the image. The final step is to clean up the edges using a white pencil.

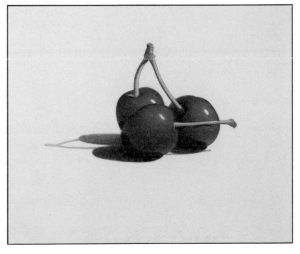

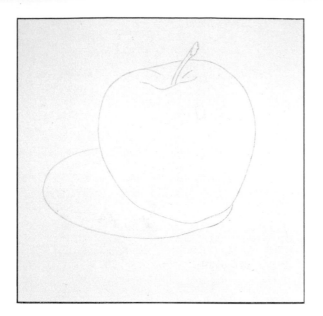

APPLE

1) In the first step, I have tranferred the line drawing to the art board. Next, I went over the outline of the apple in Scarlet Red, the shadow in Indigo Blue, and the highlight in Yellow.

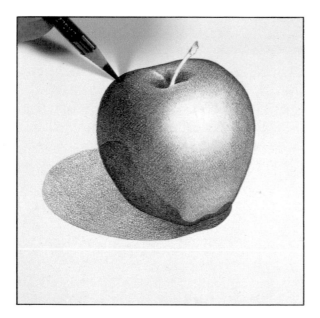

2) I begin by drawing in the basic tones with a layer of Indigo Blue. Notice the reflection of the shadow on the side of the apple.

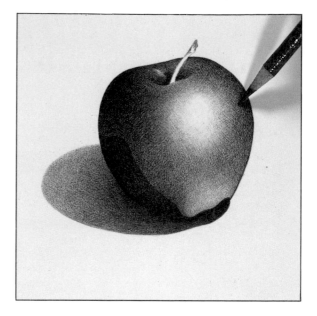

3) In the third phase, I have done the same thing except, this time, I have done it with Tuscan Red. Together with the Indigo Blue, the Tuscan Red takes on a greyish quality.

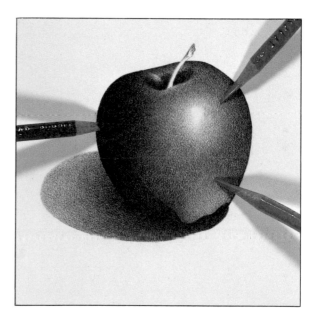

4) In order that the finished drawing might have a rich variation of color, I have add three new colors to the apple. An orange layer in the highlight area, Apple Green in the reflected light area and Purple in the shadow area of the apple.

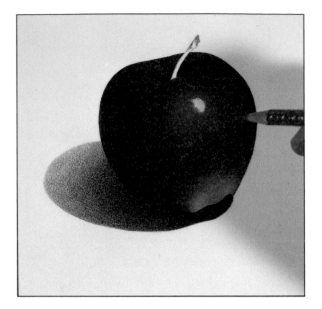

5) Next, I have applied a heavy layer of Scarlet Red and blended it in with White. The same is done in the dark area with Tuscan Red. In the reflected light area, I have used more white than red to blend the green into the red of the apple. I also darkened the shadow with Indigo Blue.

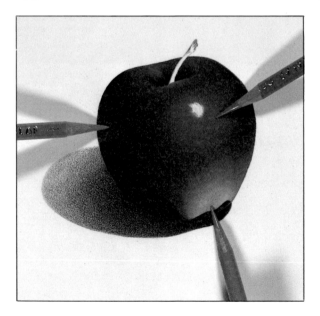

6) Again I add Orange to the highlight area and Apple Green to the reflected light area. Next, I apply Light Violet to the shadow side of the apple.

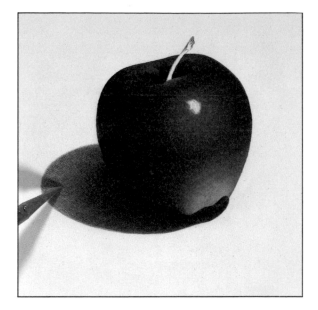

7) The next step is to finish the shadow with layers of Indigo Blue, Tuscan Red and Apple Green. Each layer is blended with white before the next is applied.

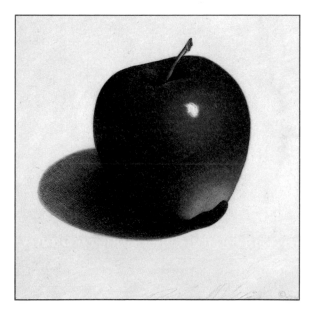

8) In the final step, the stem has been completed with Indigo Blue, Tuscan Red, Orange, Apple Green, Light Violet and Cream. A light layer of Cream has been applied to the background. Next, the edges of the apple and shadow are made smooth with a hard white pencil. Finally, the art work is signed and a spray fixative is applied.

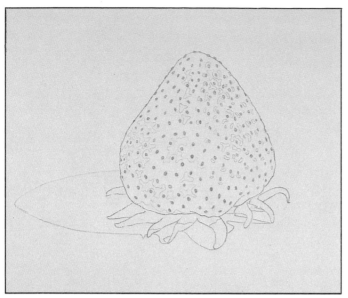

STRAWBERRY

1) As in the other drawings, the first step is to get the line drawing on the art board. The lines are, again, retraced using Indigo Blue on the shadow, Tuscan Red on the strawberry, Olive Green for the leaves and Flesh for the highlight areas of the strawberry.

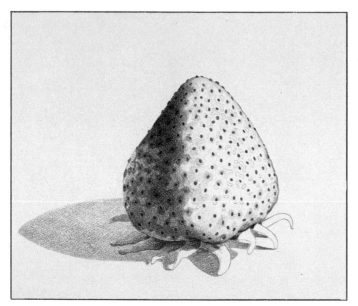

2) Next, the image is drawn in with Indigo Blue, being careful not to apply too much blue.

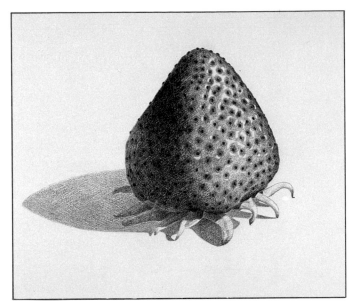

3) The next step is to add a fairly heavy layer of Tuscan Red. Make sure you maintain the patterns of dark and light.

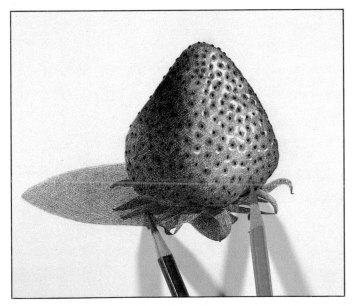

4) In this step, the leaves have been drawn in with Olive Green. Also, a layer of Apple Green has been added to the lower part of the strawberry.

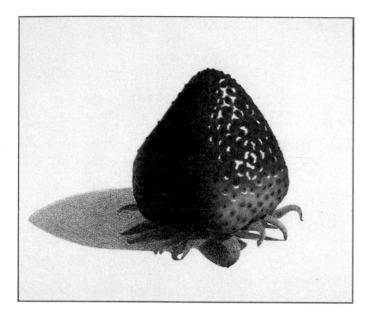

5) In this phase, I have added some warm and cool reds to the strawberry. On the shadow side, I used Crimson Red, Carmine Red and a little Purple. On the highlight side, I used Scarlet Red. Next, these colors were blended with a hard white pencil. Light Violet was used to add the highlights on the seeds.

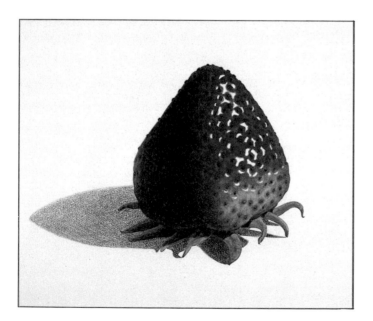

6) Next, the leaves were completed with Apple Green, Light Violet, and Warm Grey Very Light. In the shadow area, I added a small amount of Purple to darken the leaves. Some detail was added to the leaves with Scarlet Red.

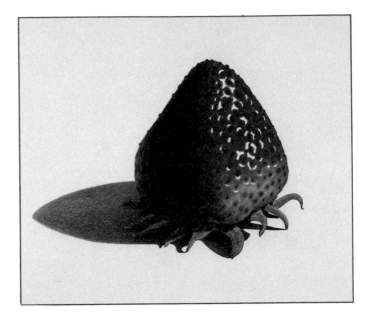

7) To complete the shadow, layers of Indigo Blue and Tuscan Red were applied and blended with a hard white pencil. A small amount of Light Violet was added to the far edge of the shadow to enrich the overall color.

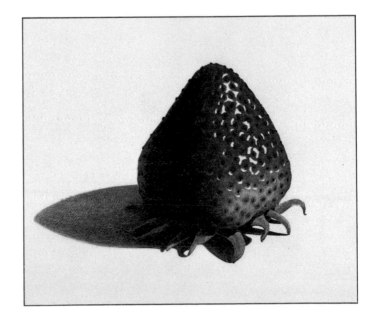

8) To complete the drawing, I used very small amounts of Scarlet Red, Orange and Yellow Ochre around the edges of the strawberry and the shadow. Then, I went over the edges with white. When this was finished, I used a spray fixative.

GRAPES

1) In the first step, the line drawing has been made and transferred to the art board in the usual way. In this case, the paper was 100% cotton with a medium surface.

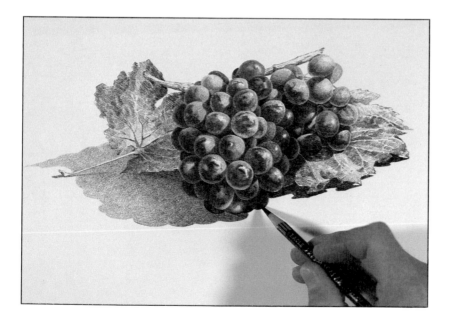

2) The next step is to fill in the value scheme. This is accomplished by using Cool Medium and Cool Grey Dark pencils. Notice at this point the texture is rough, but the image is completely modeled.

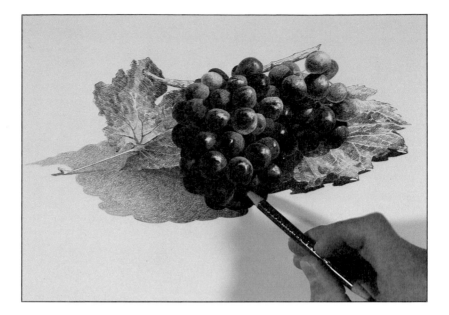

3) A layer of Tuscan Red is now added to the grapes. Since not every grape is the same, some will have more red than others. The texture is still rough at this point.

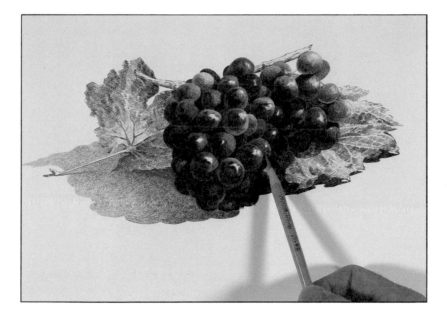

4) The grapes have a number of variations in color. To recreate this effect, I have added Apple Green to some and Orange to others.

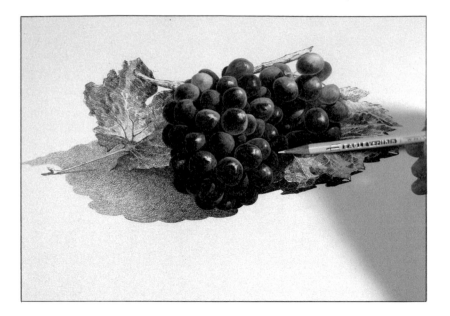

5) The next step is very important. One by one, the colors in each grape are carefully blended with a hard white pencil. Now compare the grapes from Figure 4 to Figure 5.

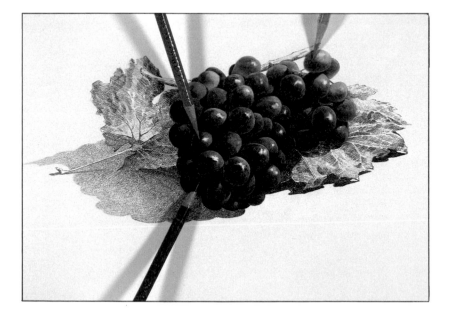

6) Again, the Apple Green and Orange are applied to the grapes. Tuscan Red and Scarlet Red are added, in places, to create a transparent look; and a layer of Indigo Blue is applied to grapes on the shadow side.

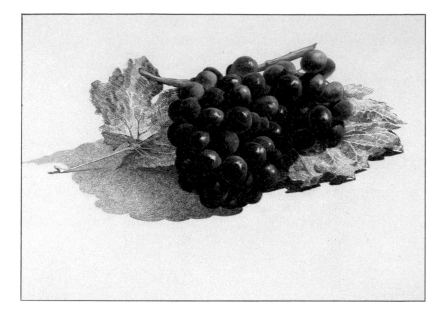

7) In this step, the stem is finished using Apple Green, Orange, Cool Grey Light, Light Violet and White.

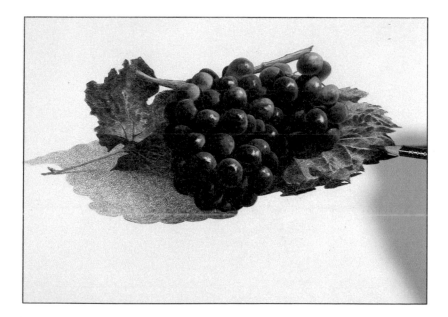

8) The first layers of color are added to the leaves. Olive Green covers the entire area while Apple Green is added to the transparent areas, and Indigo Blue is added to the shadow areas.

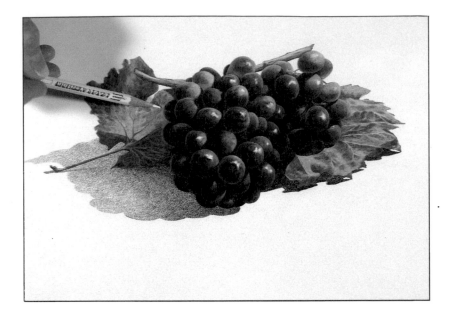

9) A hard white pencil is used next to blend the greens in the leaves. Again the two greens are reapplied. This time, they are blended with Cool Grey Very Light and Warm Grey Light to give a slight variation to the color.

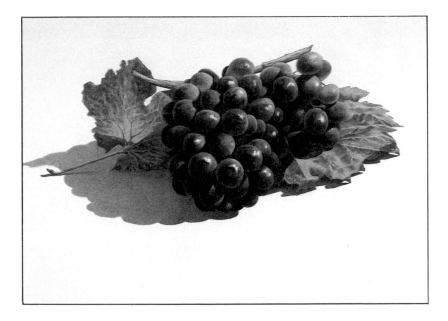

10) The shadow is the last area to be filled in. This is done first with layers of Indigo Blue and Tuscan Red. Next, they are blended with White and again the colors are applied. This procedure is continued until the desired effect is achieved.

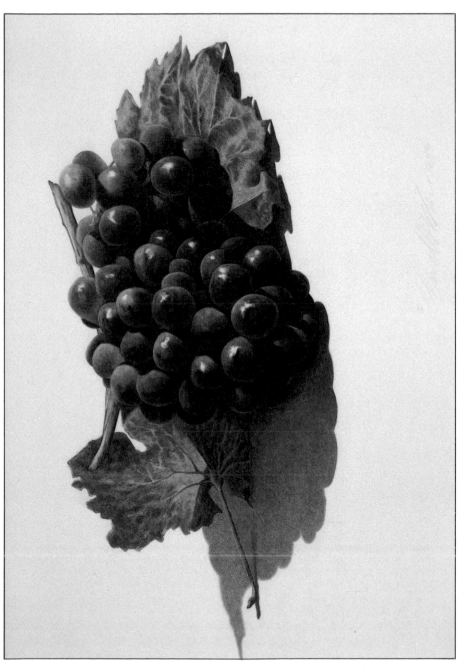

11) The main objective of the final step is to clean up the edges. This is done by drawing around the outside of the object with white. Sometimes, I also add a tiny amount of bright color to the edge to create the illusion of light bending around the object. Finally, the work is signed and a fixative is used. A fixative MUST be used on your colored pencil drawings.

ILLUSTRATION

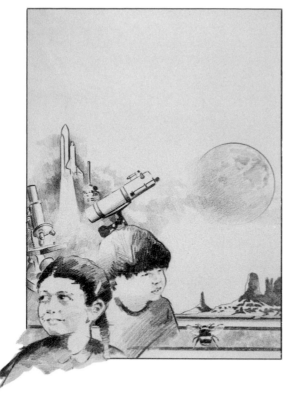

From time to time, you may have an opportunity to do an illustration. This one was done for a local junior science club. Illustrations differ from fine line art in their purpose or intent. The intent of this particular illustration was to create the feeling of children being involved with the various sciences.

1) I started this illustration by finding various elements to form a kind of collage of images. Next, on a piece of yellow tinted paper, the rough drawing was done with black colored pencil.

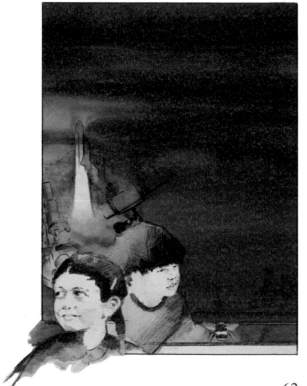

2) In the second step, the color was applied over the drawing using transparent watercolor. As you can see, using this kind of pigment, the drawing underneath is not blocked out. I used Hookers Green, Rose Carthame, Magenta, Olive Green, Prussian Blue and Yellow.

3) In the next step, a spattering. technique was used to add the stars to the sky. This is done by loading the bristles of an old toothbrush with white paint and, while holding it above your art, brushing the bristles with the blade of a knife thus throwing the paint on to the art.

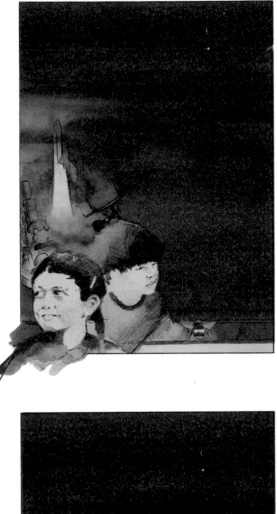

4) Using a white pencil, I added some contrast to the mountains, added the detail to the moon and redefined the objects on the left-hand side of the page.

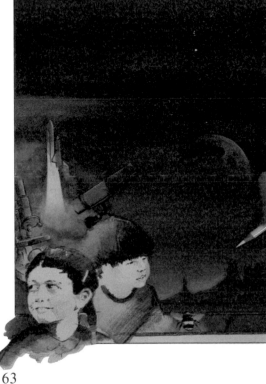

5) In the final step, I have added more color and detail to the image. Pink and Orange have been added to the sky while Non Photo Blue and Apple Green were added to the area around the objects.